DRAWING
HANDS

CARL CHEEK

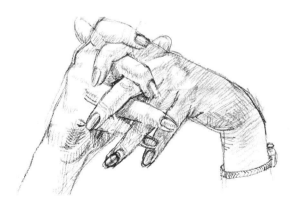

DOVER PUBLICATIONS, INC.
MINEOLA, NEW YORK

Bibliographical Note

This Dover edition, first published in 2008, is an unabridged republication of the work originally published by Pitman Publishing Corporation, New York, in 1959.

Library of Congress Cataloging-in-Publication Data

Cheek, Carl.
 Drawing hands / Carl Cheek.
 p. cm.
 Originally published: New York: Pitman Pub. Corp., 1959.
 ISBN-13: 978-0-486-46597-5
 ISBN-10: 0-486-46597-7
 1. Hands in art. 2. Drawing—Technique. I. Title.

NC774.C47 2008
743.4'9—dc22

2007041489

Manufactured in the United States by Courier Corporation
46597703 2014
www.doverpublications.com

INTRODUCTION

At the outset I should like to make clear the fact that there is no specific rule or formula for drawing any object and that the hand is no exception.

In view, however, of the complexity of form and movement inherent in hands, it is true that they do present many difficulties to the draughtsman and painter.

The achievement of fullness, variety and clarity at one and the same time is always a problem and particularly so, it seems, in dealing with the forms of the hand.

The fact that we are aware of being surrounded more often by clothed individuals than otherwise has led to our being almost as conditioned in our attitude to hands as we have become to the human face. They have come to be regarded as expressive features (emotive fragments) of the human being, subsidiary only to the face, and our incurious familiarity with them continually comes between us and any endeavor to view them in an objective or dispassionate manner.

It is then rather on account of their familiarity to us than the reverse that they are deserving if not demanding of separate study, and it is my hope that the following drawings, diagrams and text may be of real service and not merely an aid to the accumulation of a series of smart tricks to be applied mechanically.

When dealing with any of the forms in nature, and by that I mean everything around us, a process of rationalization takes place: We endeavor to reduce an object to simple understandable terms by considering its function and its component parts separately.

Such an element of analysis is present in every drawing of worth, although in the case of master drawings it is not always apparent, occurring, as it does, instinctively and almost at the moment of execution.

It should be borne in mind that although we shall be observing the nature of hands separately, it is important that we continually remind ourselves of the fact that they form a part only of a larger unit—the human figure—and are only fully expressive when related to it.

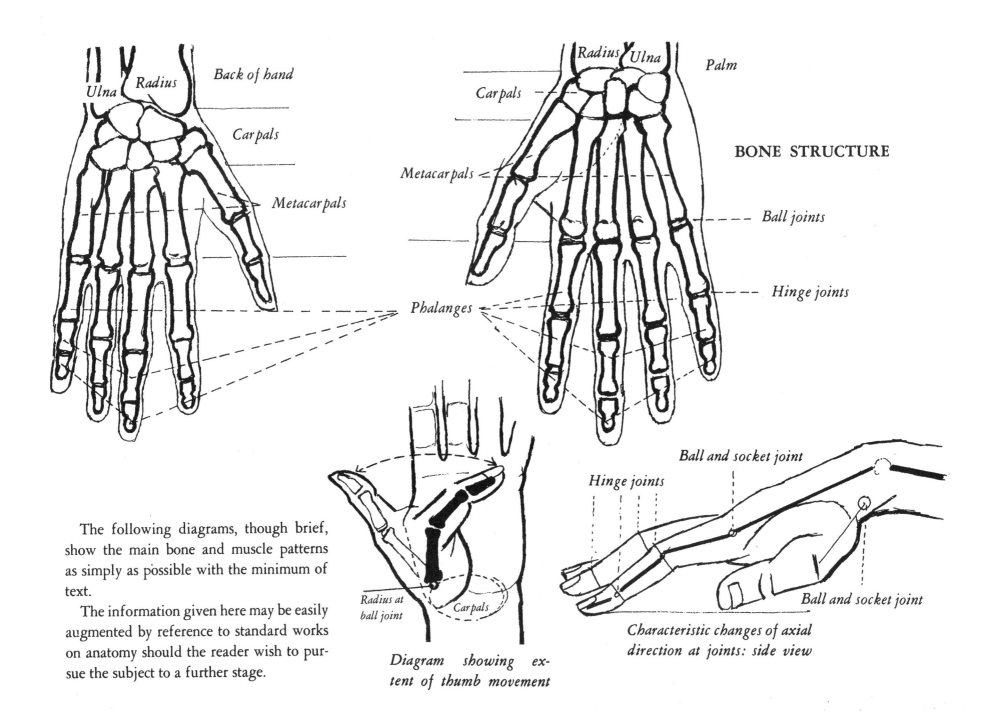

Back of hand

Ulna Radius

Carpals

Metacarpals

Phalanges

Radius Ulna Palm

Carpals

BONE STRUCTURE

Metacarpals

Ball joints

Hinge joints

Phalanges

The following diagrams, though brief, show the main bone and muscle patterns as simply as possible with the minimum of text.

The information given here may be easily augmented by reference to standard works on anatomy should the reader wish to pursue the subject to a further stage.

Radius at ball joint Carpals

Diagram showing extent of thumb movement

Hinge joints Ball and socket joint

Ball and socket joint

Characteristic changes of axial direction at joints: side view

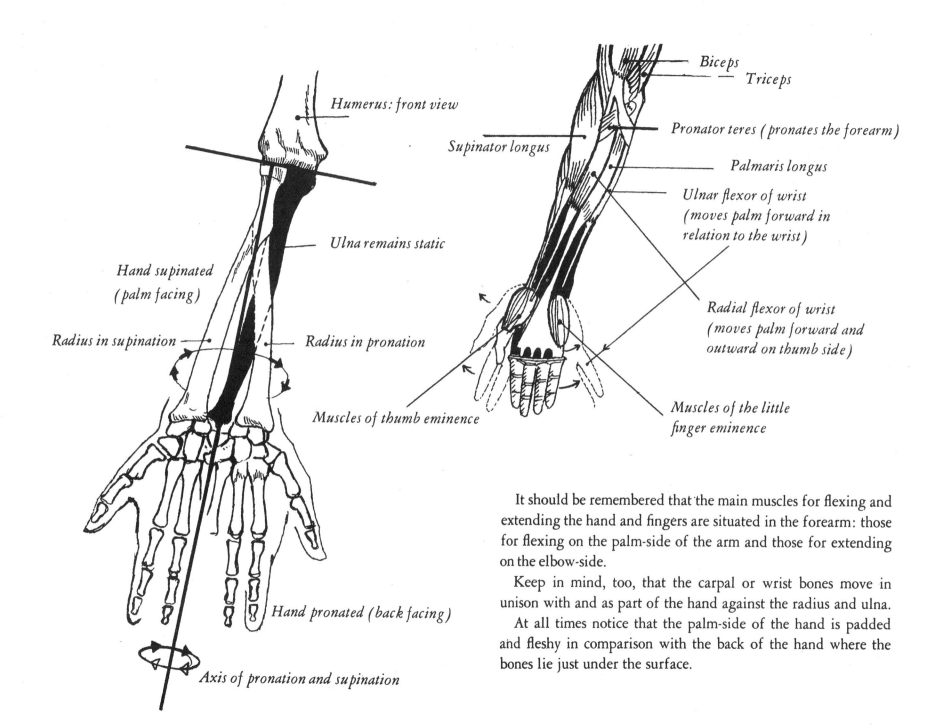

Humerus: front view

Ulna remains static

Hand supinated
(palm facing)

Radius in supination

Radius in pronation

Muscles of thumb eminence

Hand pronated (back facing)

Axis of pronation and supination

Biceps

Triceps

Supinator longus

Pronator teres (pronates the forearm)

Palmaris longus

Ulnar flexor of wrist
(moves palm forward in
relation to the wrist)

Radial flexor of wrist
(moves palm forward and
outward on thumb side)

Muscles of the little
finger eminence

It should be remembered that the main muscles for flexing and extending the hand and fingers are situated in the forearm: those for flexing on the palm-side of the arm and those for extending on the elbow-side.

Keep in mind, too, that the carpal or wrist bones move in unison with and as part of the hand against the radius and ulna.

At all times notice that the palm-side of the hand is padded and fleshy in comparison with the back of the hand where the bones lie just under the surface.

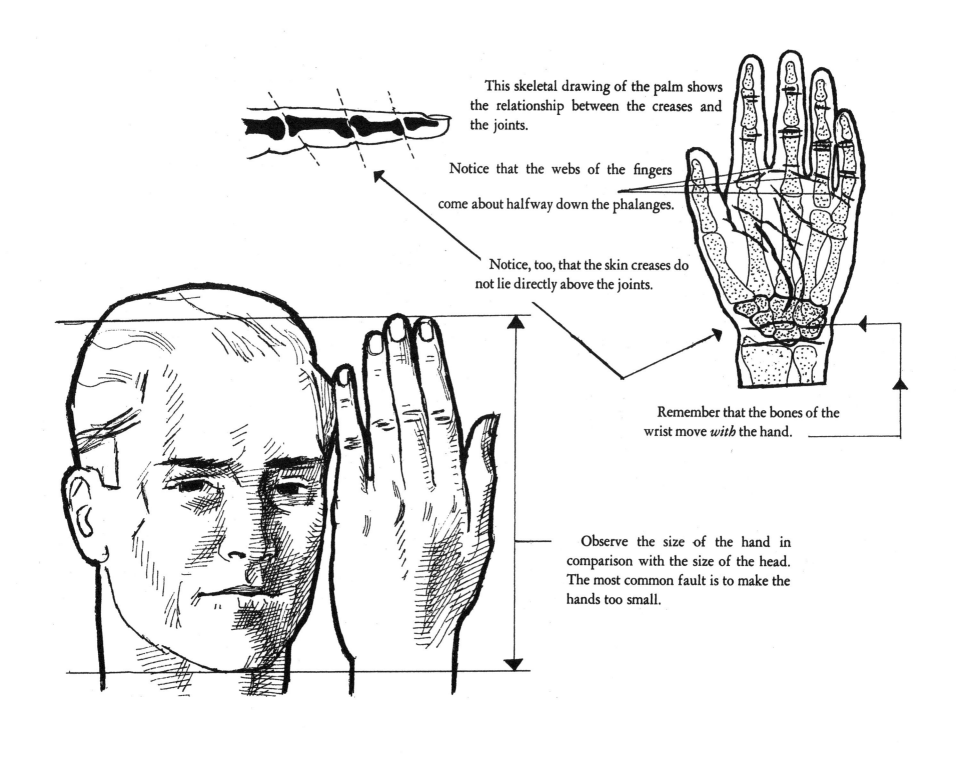

This skeletal drawing of the palm shows the relationship between the creases and the joints.

Notice that the webs of the fingers come about halfway down the phalanges.

Notice, too, that the skin creases do not lie directly above the joints.

Remember that the bones of the wrist move *with* the hand.

Observe the size of the hand in comparison with the size of the head. The most common fault is to make the hands too small.

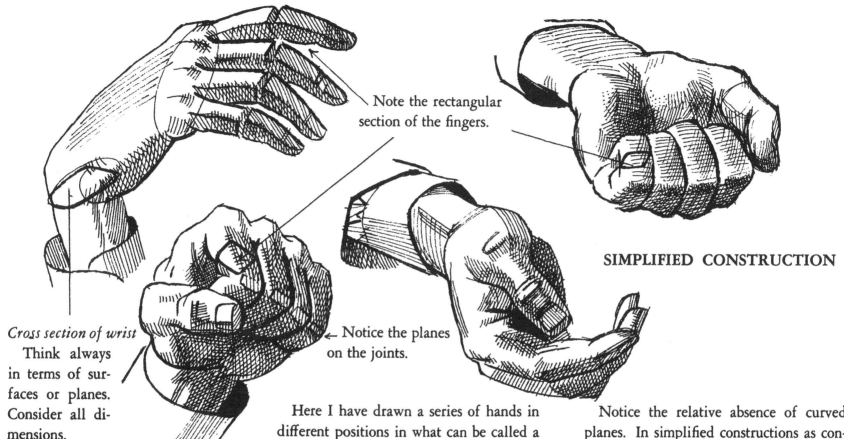

Note the rectangular
section of the fingers.

Cross section of wrist
Think always
in terms of sur-
faces or planes.
Consider all di-
mensions.

← Notice the planes
on the joints.

SIMPLIFIED CONSTRUCTION

Here I have drawn a series of hands in different positions in what can be called a three-dimensional diagram form. That is to say that only the simplest surfaces or planes have been employed in building up the structure.

This type of drawing by means of basic solid geometry forms is very valuable in developing a feeling for essentials and may be profitably used as a preliminary probe when you are faced with complexities which might otherwise appear insoluble.

Notice the relative absence of curved planes. In simplified constructions as contrasted with finished drawings nearly all the surfaces meet at a definite angle. This is to remind ourselves that everything, no matter what, has front, back, sides, top, and bottom.

Use this diagram form before beginning *any* drawing, but keep it separate and do not attempt to superimpose the finished drawing over it.

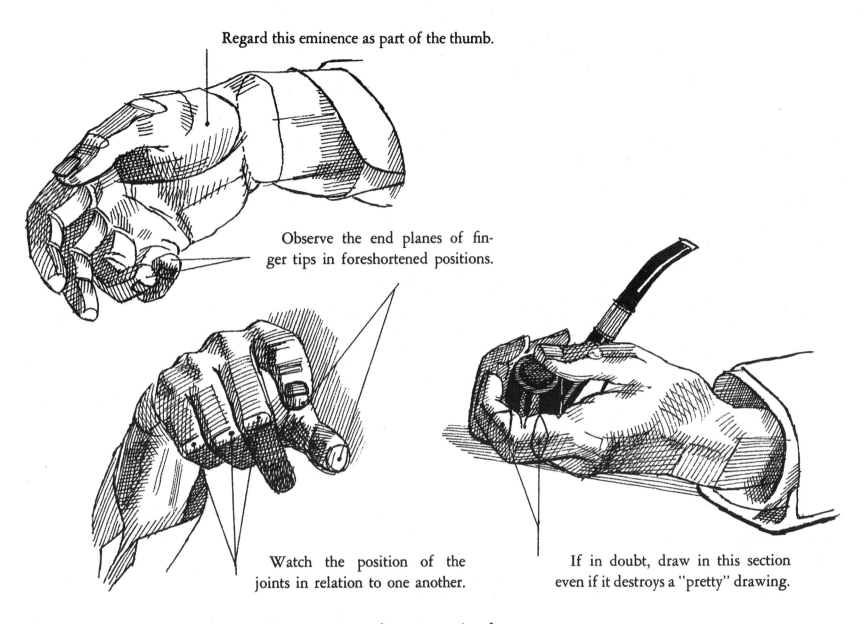

Regard this eminence as part of the thumb.

Observe the end planes of finger tips in foreshortened positions.

Watch the position of the joints in relation to one another.

If in doubt, draw in this section even if it destroys a "pretty" drawing.

Think always of the structure and never merely of the silhouette. Only in this way will you learn to draw with expressiveness.

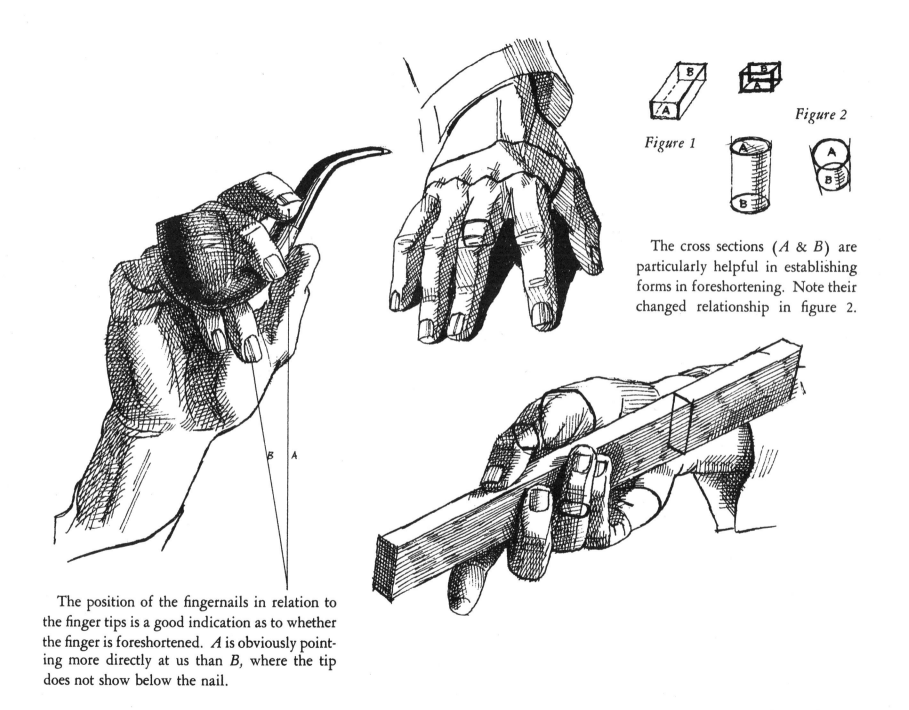

Figure 1

Figure 2

The cross sections (*A* & *B*) are particularly helpful in establishing forms in foreshortening. Note their changed relationship in figure 2.

The position of the fingernails in relation to the finger tips is a good indication as to whether the finger is foreshortened. *A* is obviously pointing more directly at us than *B*, where the tip does not show below the nail.

LATERAL WRIST MOVEMENT

As can be seen from these diagrams, the lateral movement of the hand at the wrist in either direction is more restricted than the forward and backward movement shown on the following page.

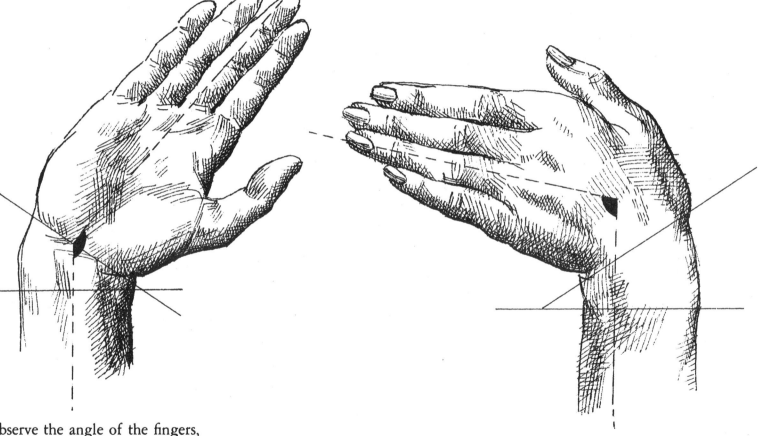

Observe the angle of the fingers, shown by the dotted line, relative to the wrist. The movement shown is restricted, and the angle formed is thus obtuse (more than 90°).

This movement (toward center of the body) is less restricted than the other. The angle formed by the fingers and wrist is less obtuse.

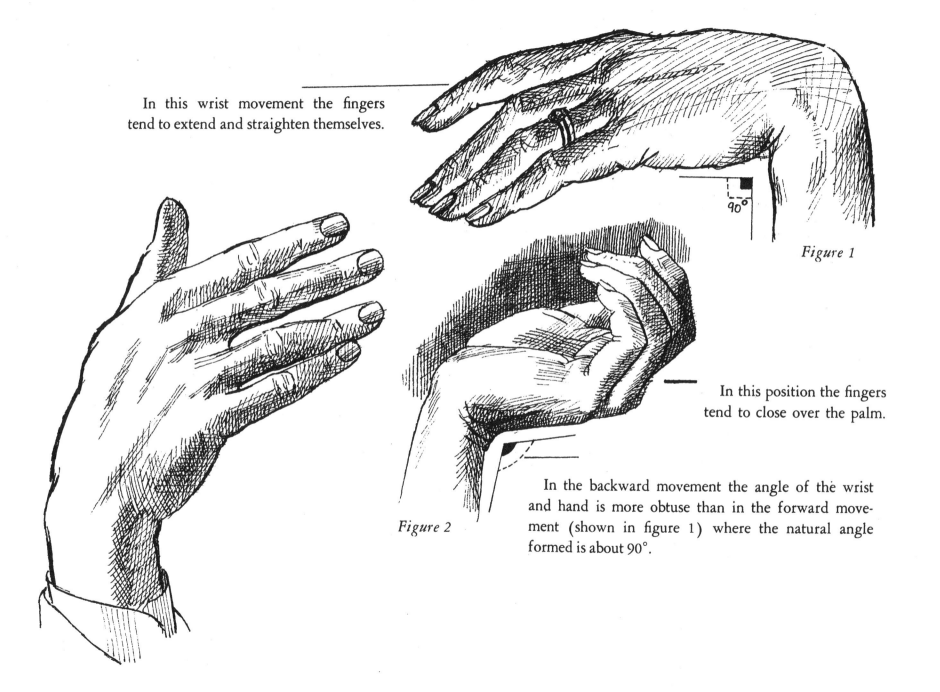

In this wrist movement the fingers tend to extend and straighten themselves.

Figure 1

In this position the fingers tend to close over the palm.

In the backward movement the angle of the wrist and hand is more obtuse than in the forward movement (shown in figure 1) where the natural angle formed is about 90°.

Figure 2

90°

Notice how cushioned and fleshy the palm looks in comparison with the boniness of the back of the hand.

The movements shown on this page are the same as those on the preceding page, but the hands are viewed from different angles.

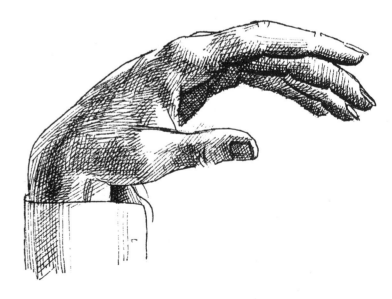

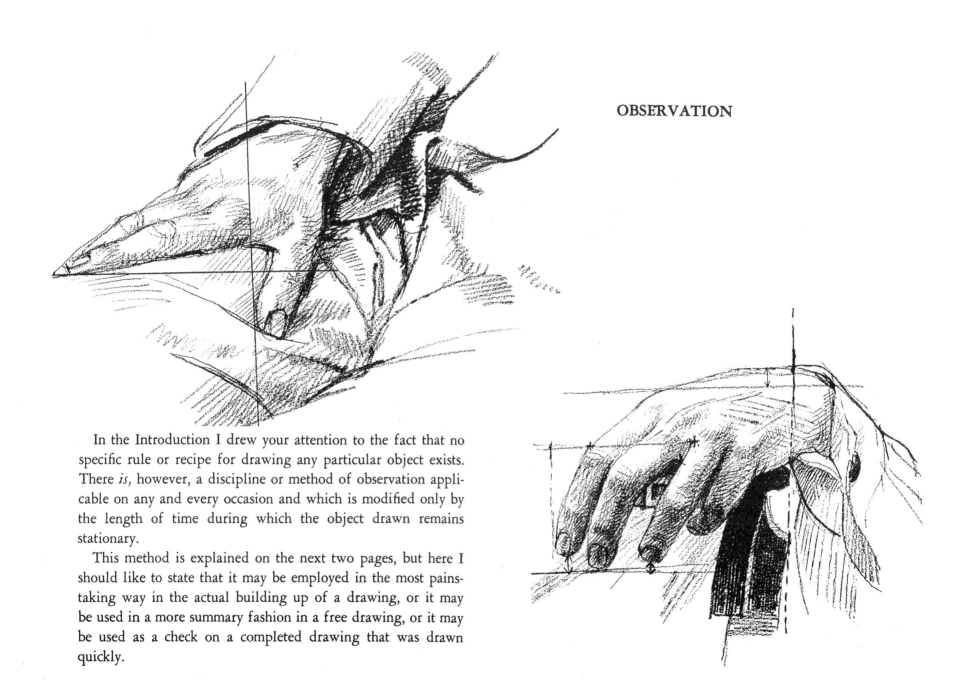

In the Introduction I drew your attention to the fact that no specific rule or recipe for drawing any particular object exists. There *is,* however, a discipline or method of observation applicable on any and every occasion and which is modified only by the length of time during which the object drawn remains stationary.

This method is explained on the next two pages, but here I should like to state that it may be employed in the most painstaking way in the actual building up of a drawing, or it may be used in a more summary fashion in a free drawing, or it may be used as a check on a completed drawing that was drawn quickly.

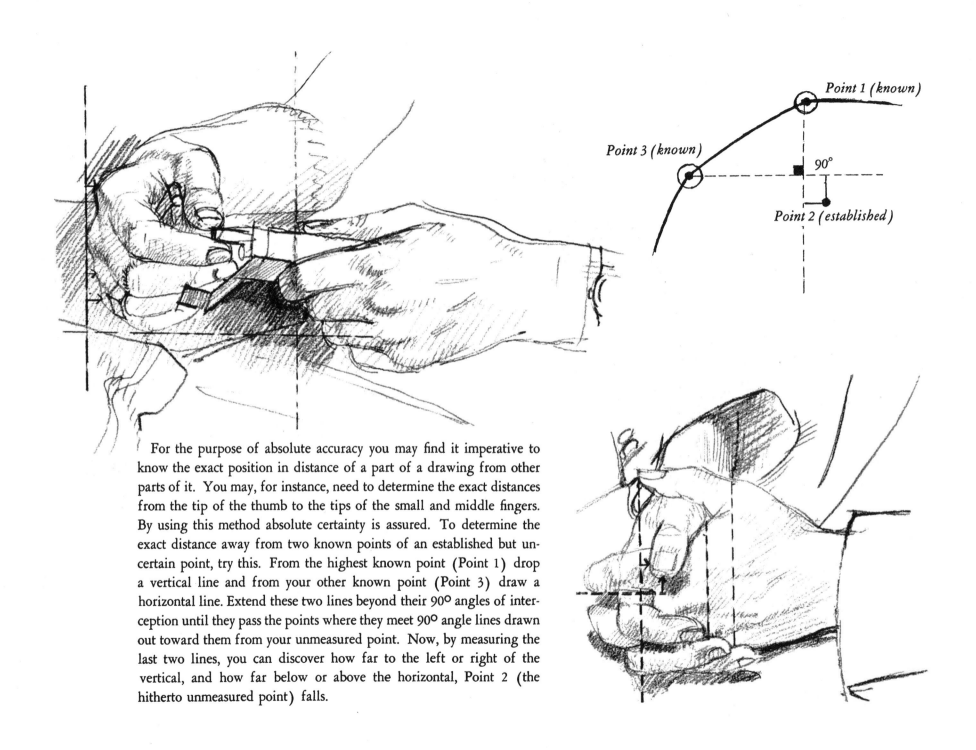

Point 1 (known)

Point 3 (known)

90°

Point 2 (established)

For the purpose of absolute accuracy you may find it imperative to know the exact position in distance of a part of a drawing from other parts of it. You may, for instance, need to determine the exact distances from the tip of the thumb to the tips of the small and middle fingers. By using this method absolute certainty is assured. To determine the exact distance away from two known points of an established but uncertain point, try this. From the highest known point (Point 1) drop a vertical line and from your other known point (Point 3) draw a horizontal line. Extend these two lines beyond their 90° angles of interception until they pass the points where they meet 90° angle lines drawn out toward them from your unmeasured point. Now, by measuring the last two lines, you can discover how far to the left or right of the vertical, and how far below or above the horizontal, Point 2 (the hitherto unmeasured point) falls.

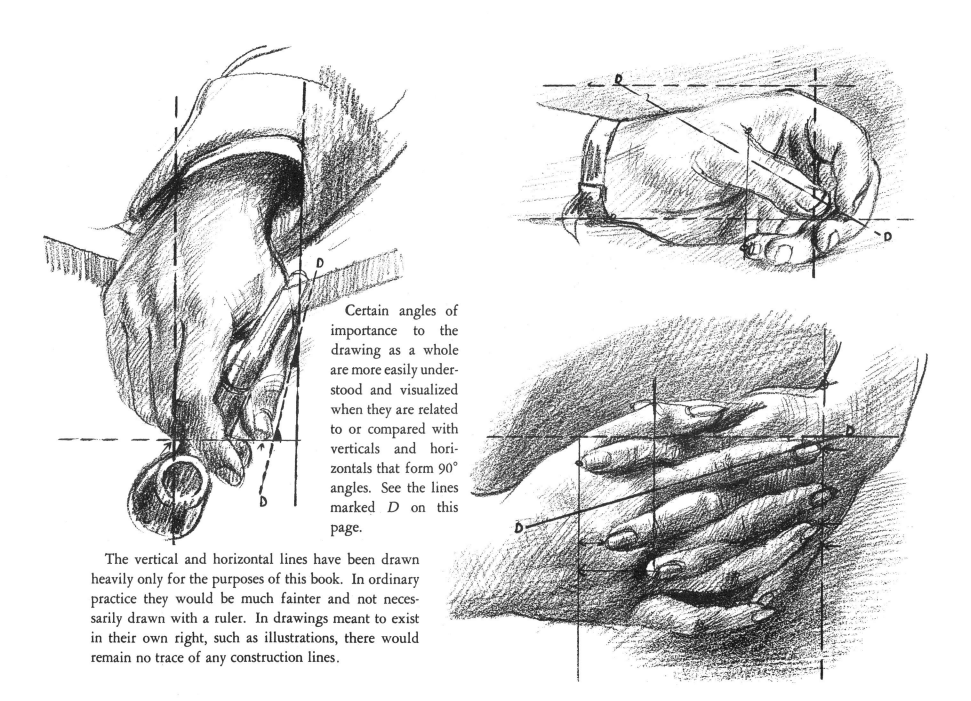

Certain angles of importance to the drawing as a whole are more easily understood and visualized when they are related to or compared with verticals and horizontals that form 90° angles. See the lines marked *D* on this page.

The vertical and horizontal lines have been drawn heavily only for the purposes of this book. In ordinary practice they would be much fainter and not necessarily drawn with a ruler. In drawings meant to exist in their own right, such as illustrations, there would remain no trace of any construction lines.

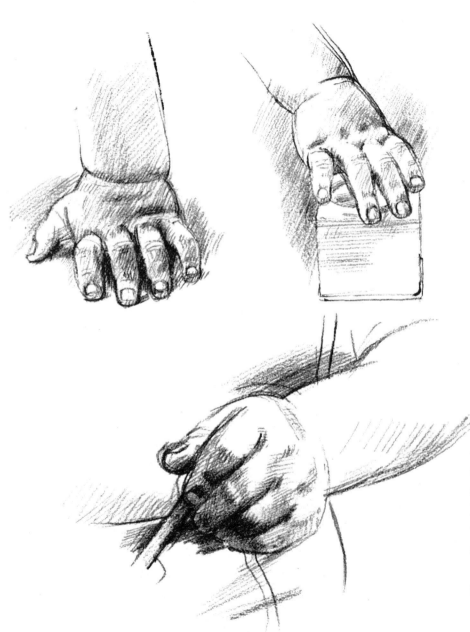

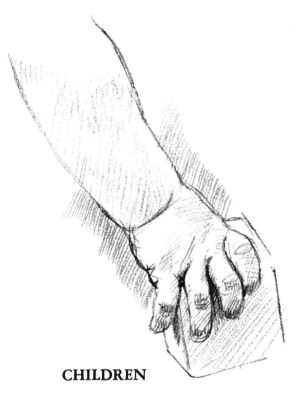

CHILDREN

The hands of children vary only in a most subtle manner from age group to age group. I have therefore concentrated on the early or infant age group, since this group provides us with the maximum difference when compared with the hands of adults. From about four years of age onward the proportions are much the same as in a mature hand, although perhaps more delicate in structure.

The infant hand is characterized by a general chubbiness, notably at the wrist and on the back. The fingers are short and well padded with flesh. There is a minimum of tapering toward the tips, and the fingernails are short and small.

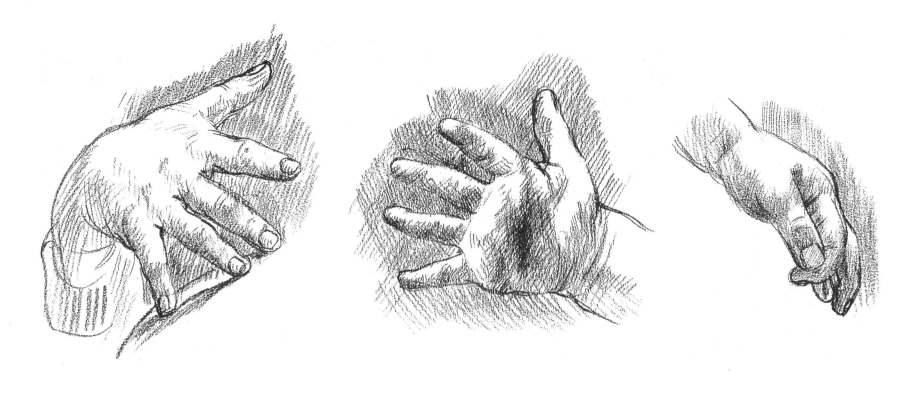

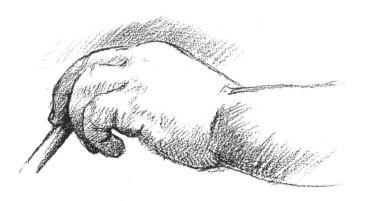

It is difficult to make any hard and fast rules about the character of children's hands. Their manifold movements and gestures alternate between fumbling and clumsiness and extreme delicacy of touch and posture. Truly, the only individuating characteristics to hold on to are those already mentioned, particularly the well-covered, fleshy look. Note also the tendency to dimples on the back of the hand.

Because children are so restless, it is almost impossible to get them to hold still long enough to observe their hands. The time to get properly to grips with this problem is when they are asleep and when it is possible to observe their hands closely between their fitful movements.

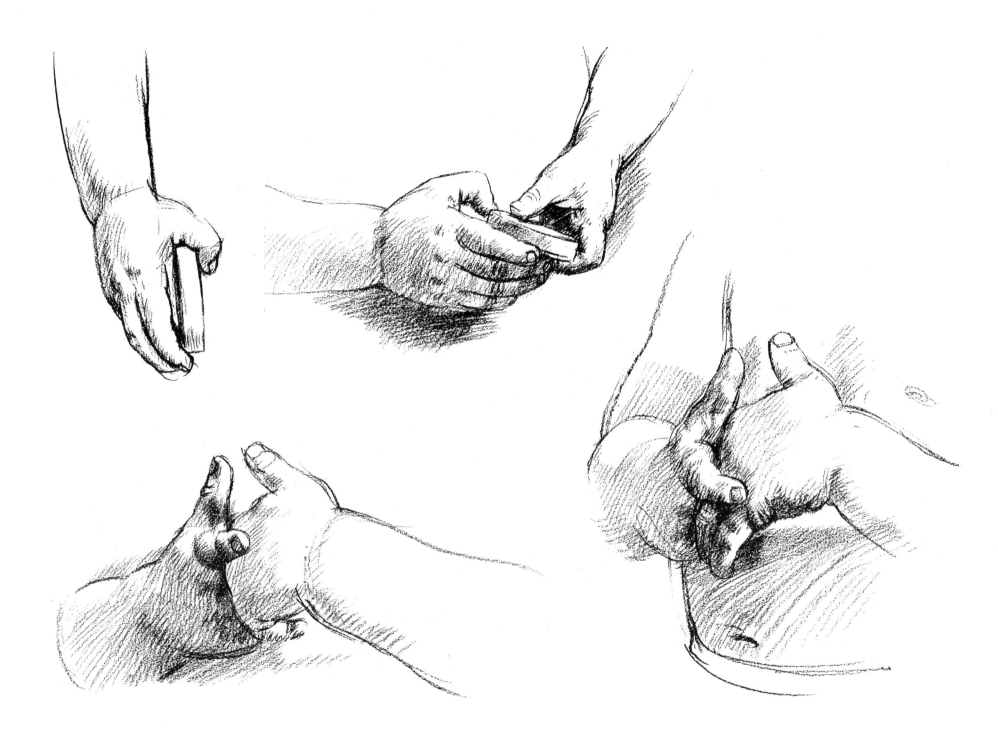

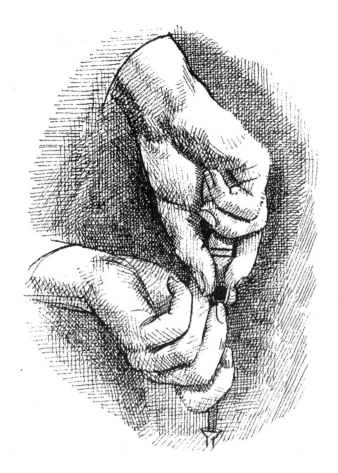

MALE HAND

The main characteristic of the male hand, as compared with the female, is its greater angularity. Consequently, the modeling of the component planes may be more decisively accentuated. Bone projections and surface textures may be similarly stressed.

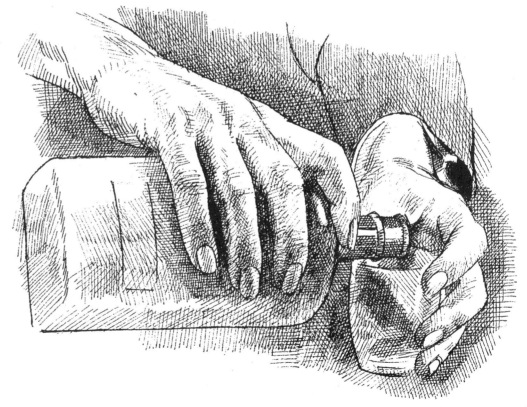

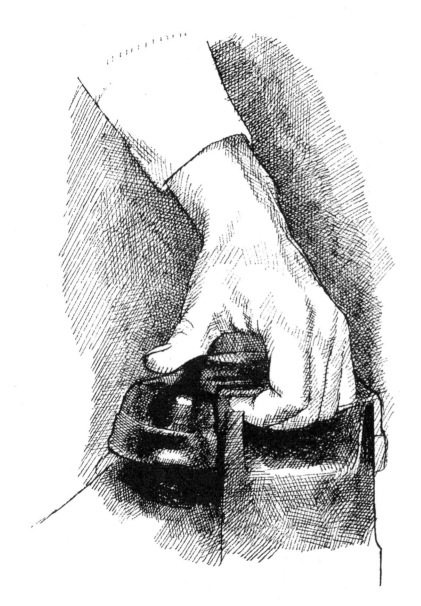

In the early stages of learning to draw *anything,* superficial differences, such as the differences between the male and the female hand, should never be unduly insisted upon. The general structure of your subject is the most important concern. Differences in character will follow naturally in your drawings as a result of your continuous observation of what lies around you.

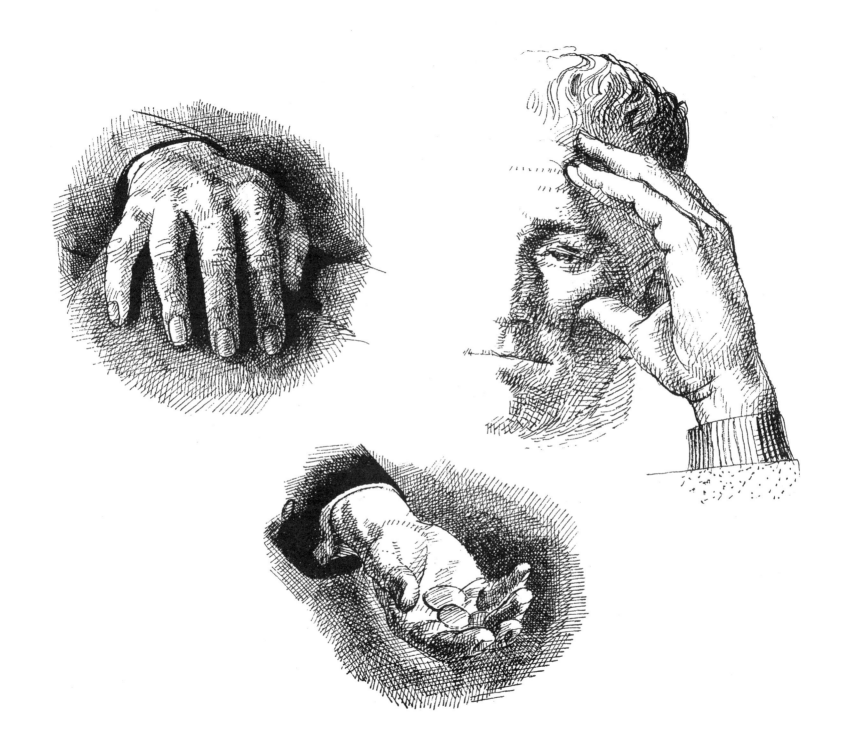

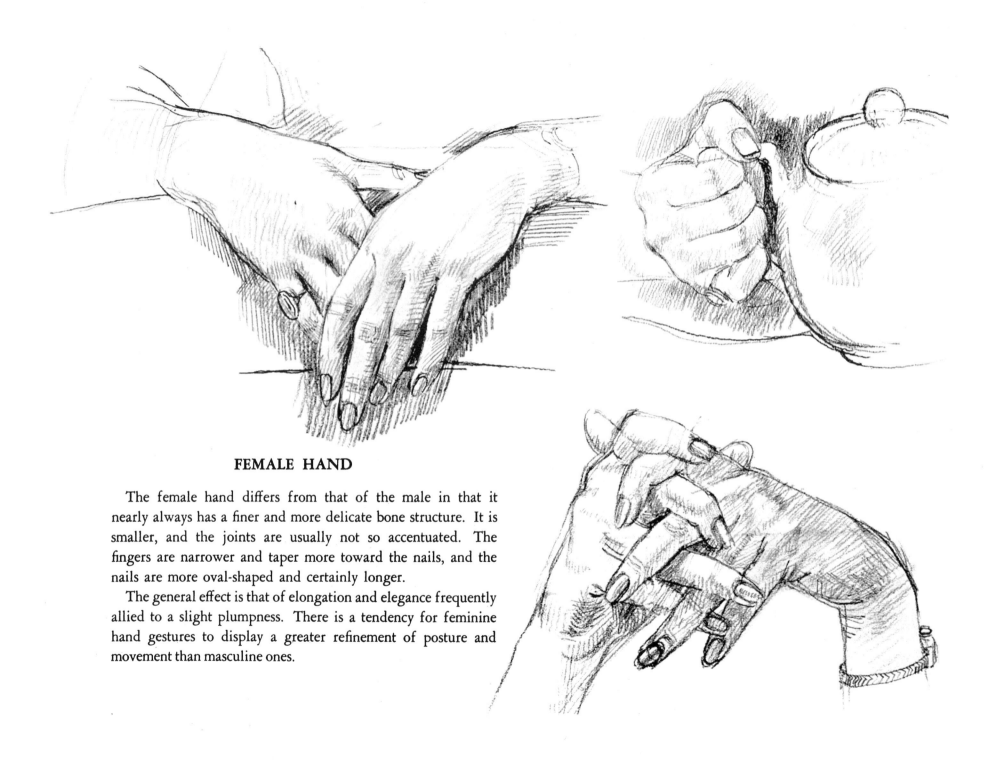

FEMALE HAND

The female hand differs from that of the male in that it nearly always has a finer and more delicate bone structure. It is smaller, and the joints are usually not so accentuated. The fingers are narrower and taper more toward the nails, and the nails are more oval-shaped and certainly longer.

The general effect is that of elongation and elegance frequently allied to a slight plumpness. There is a tendency for feminine hand gestures to display a greater refinement of posture and movement than masculine ones.

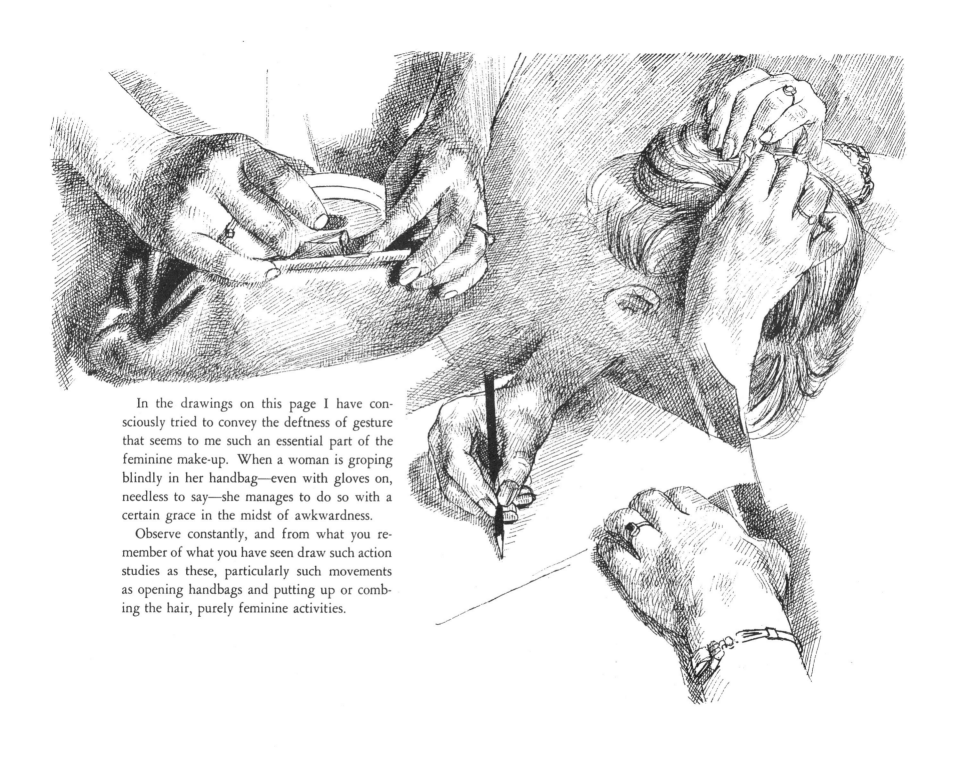

In the drawings on this page I have consciously tried to convey the deftness of gesture that seems to me such an essential part of the feminine make-up. When a woman is groping blindly in her handbag—even with gloves on, needless to say—she manages to do so with a certain grace in the midst of awkwardness.

Observe constantly, and from what you remember of what you have seen draw such action studies as these, particularly such movements as opening handbags and putting up or combing the hair, purely feminine activities.

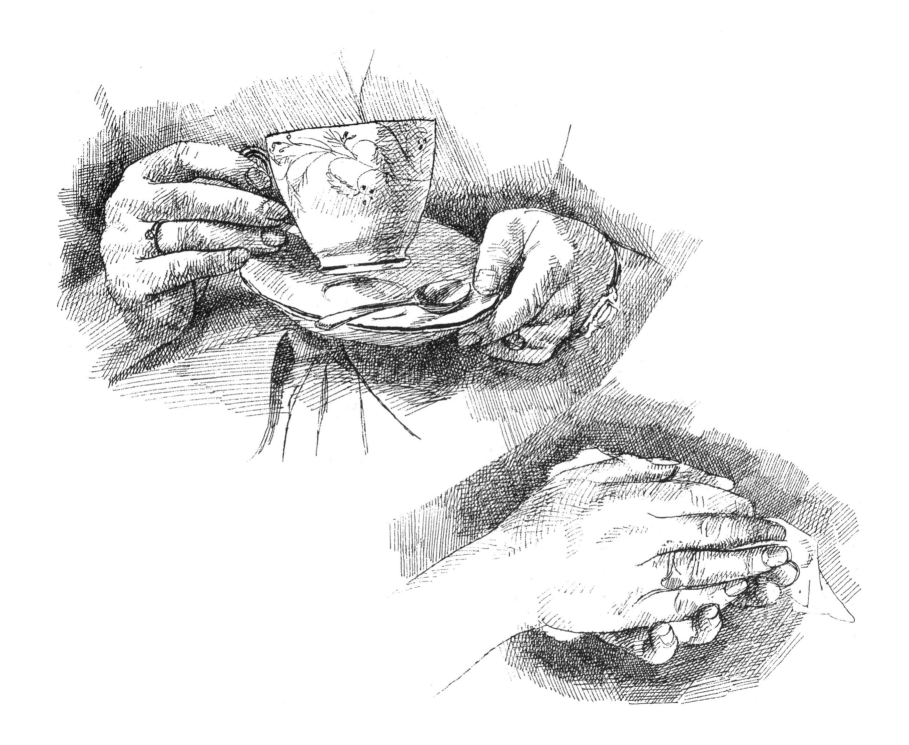

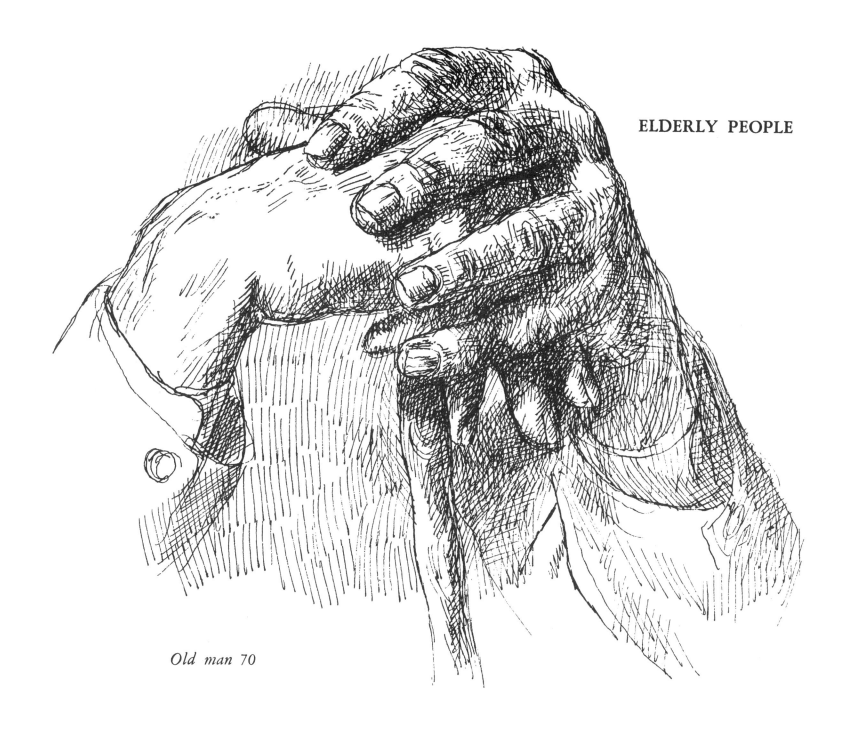

ELDERLY PEOPLE

Old man 70

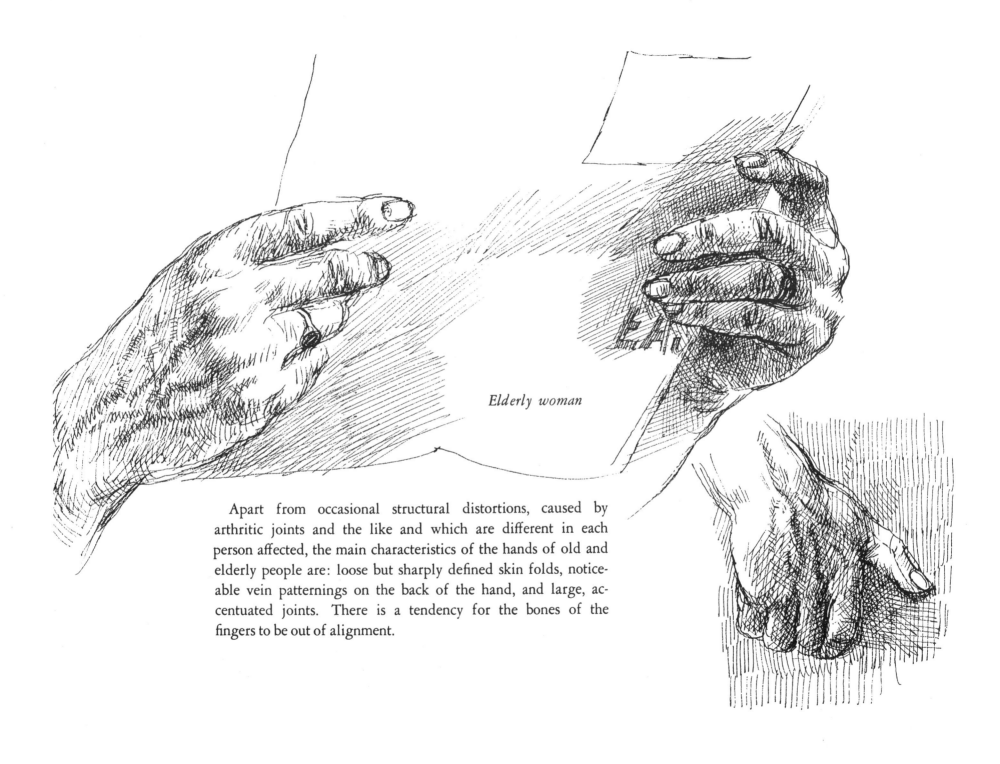

Elderly woman

Apart from occasional structural distortions, caused by arthritic joints and the like and which are different in each person affected, the main characteristics of the hands of old and elderly people are: loose but sharply defined skin folds, noticeable vein patternings on the back of the hand, and large, accentuated joints. There is a tendency for the bones of the fingers to be out of alignment.

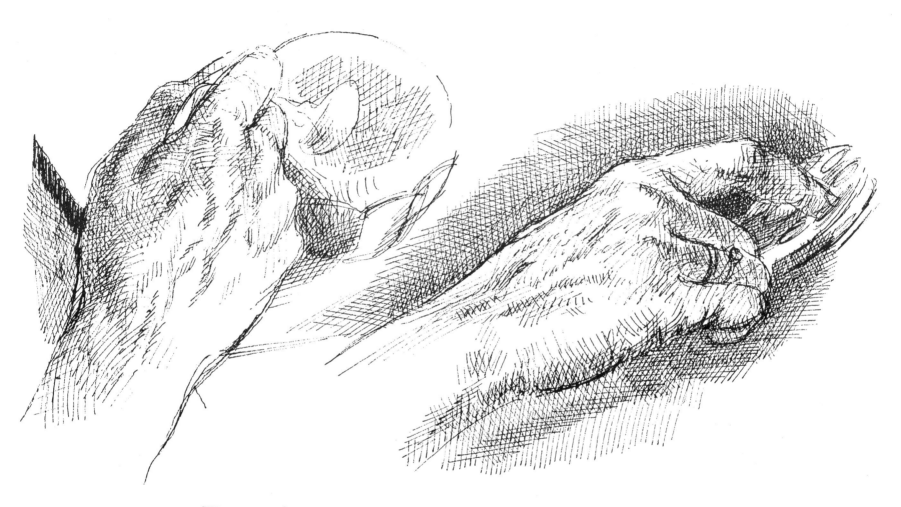

Woman early 60's

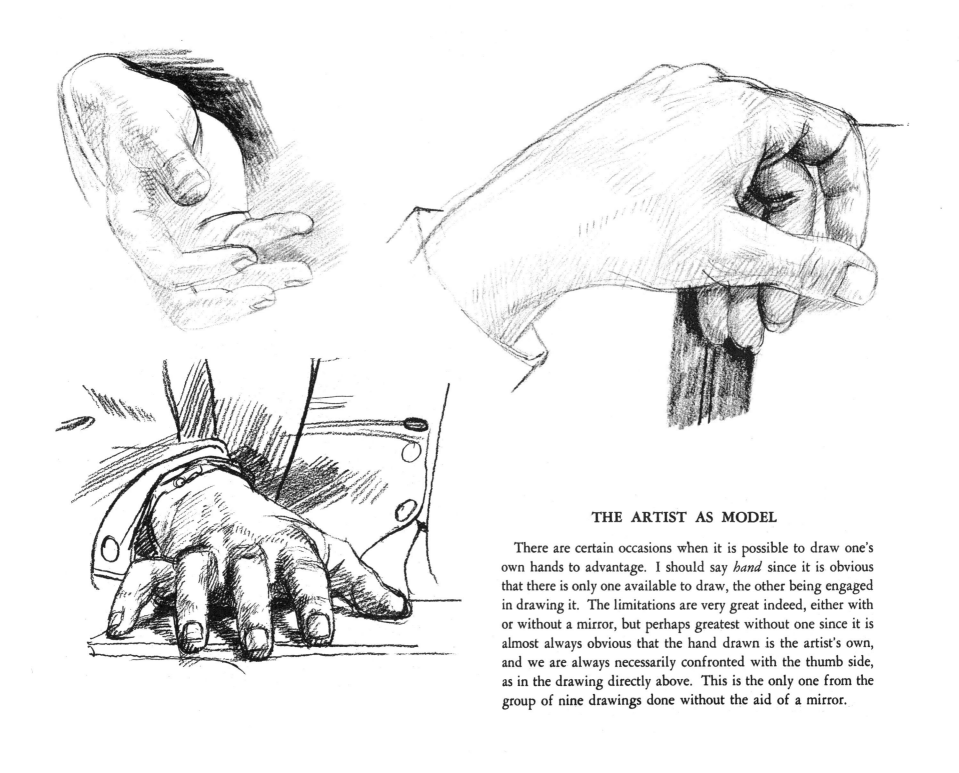

THE ARTIST AS MODEL

There are certain occasions when it is possible to draw one's own hands to advantage. I should say *hand* since it is obvious that there is only one available to draw, the other being engaged in drawing it. The limitations are very great indeed, either with or without a mirror, but perhaps greatest without one since it is almost always obvious that the hand drawn is the artist's own, and we are always necessarily confronted with the thumb side, as in the drawing directly above. This is the only one from the group of nine drawings done without the aid of a mirror.

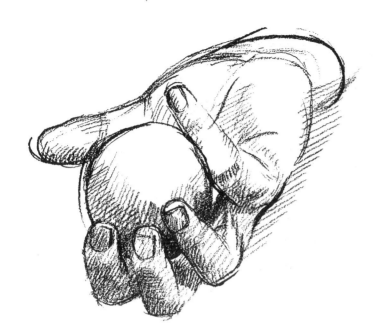

Always be sure to observe the precise shape of the nails and their relationship to the form of the finger tips. Watch how radically such relationships alter when viewed from different positions.

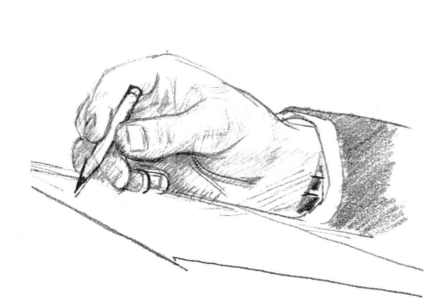

The real advantage of drawing one's own hand is of course its availability. However limited the basic view of it may be, each pose, even though similar to a preceding one, is always subtly different. So, there is more of an exercise in *drawing* and less of an anatomical study. Exploration of forms is common to most master drawings in any era.

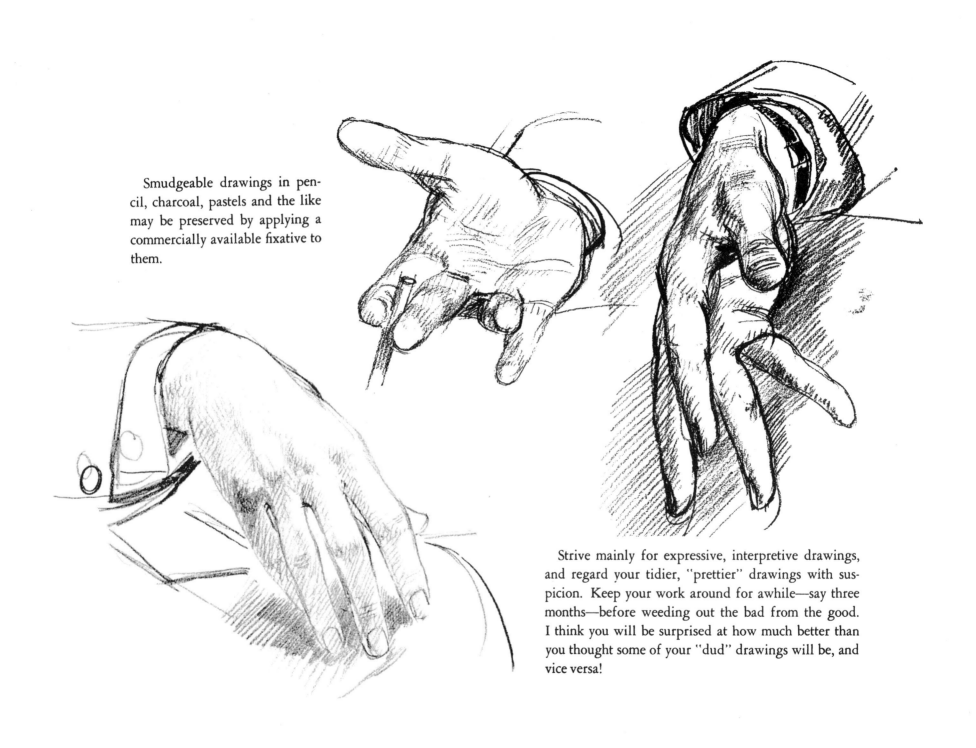

Smudgeable drawings in pencil, charcoal, pastels and the like may be preserved by applying a commercially available fixative to them.

Strive mainly for expressive, interpretive drawings, and regard your tidier, "prettier" drawings with suspicion. Keep your work around for awhile—say three months—before weeding out the bad from the good. I think you will be surprised at how much better than you thought some of your "dud" drawings will be, and vice versa!

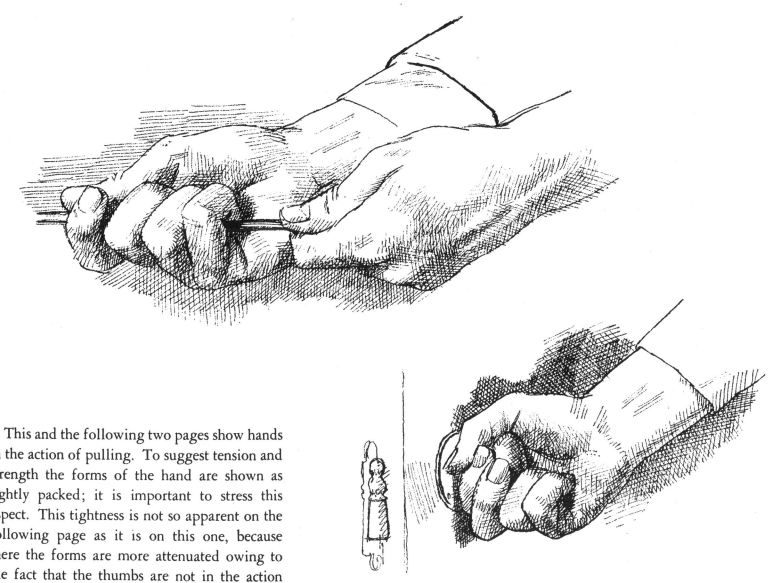

This and the following two pages show hands in the action of pulling. To suggest tension and strength the forms of the hand are shown as tightly packed; it is important to stress this aspect. This tightness is not so apparent on the following page as it is on this one, because there the forms are more attenuated owing to the fact that the thumbs are not in the action which is centered on the first and second joints of the fingers.

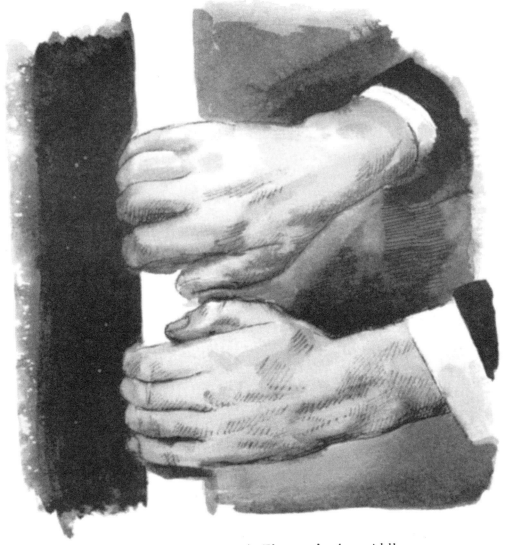

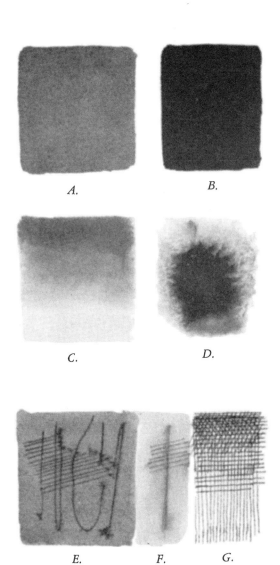

*Analysis of the tones and textures
employed in the washes*

A. *Flat wash of a middle tone*
B. *Flat wash of the darkest tone*
C. *Graded wash: pale tone applied first,
darker tone applied at the top while
the first is still wet*

D. *Very dark tone touched in on damp paper*
E. *Lines drawn on wet wash*
F. *Wash of pure water over lines made with
a nonwaterproof ink*
G. *Graded cross-hatched pen and ink lines*

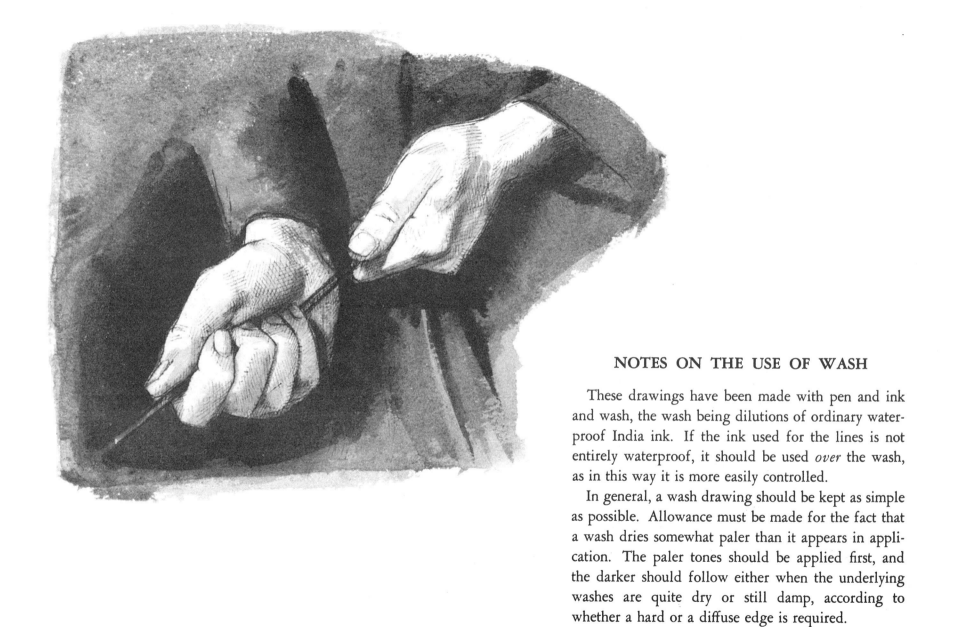

NOTES ON THE USE OF WASH

These drawings have been made with pen and ink and wash, the wash being dilutions of ordinary waterproof India ink. If the ink used for the lines is not entirely waterproof, it should be used *over* the wash, as in this way it is more easily controlled.

In general, a wash drawing should be kept as simple as possible. Allowance must be made for the fact that a wash dries somewhat paler than it appears in application. The paler tones should be applied first, and the darker should follow either when the underlying washes are quite dry or still damp, according to whether a hard or a diffuse edge is required.

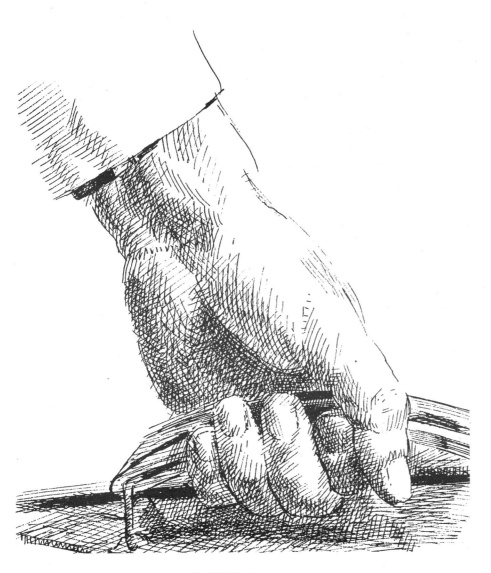

LIFTING

When employed in lifting, the fingers are directly involved in supporting the weight. As can be seen in the above drawings, the fingers are made to form a sort of hook from which the object lifted is suspended. The movements in lifting are almost identical to those of pulling, except that the tension is vertical in lifting.

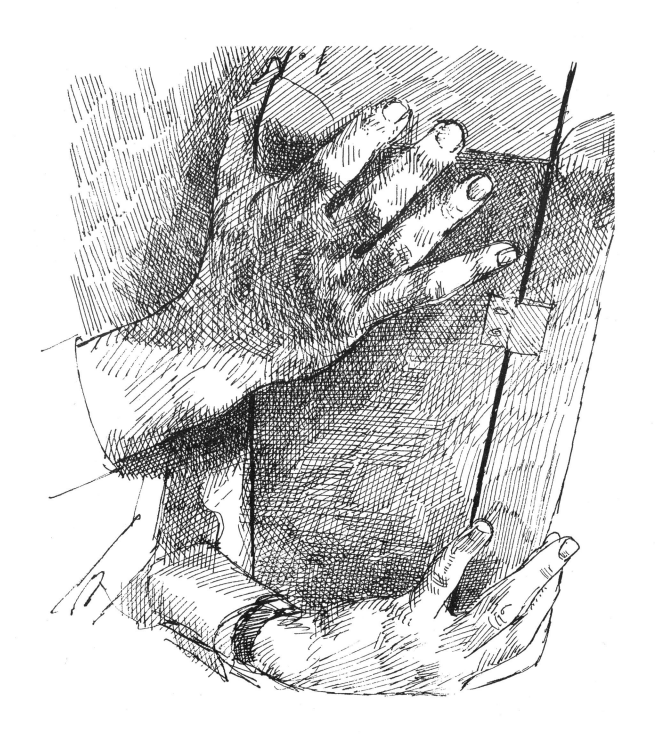

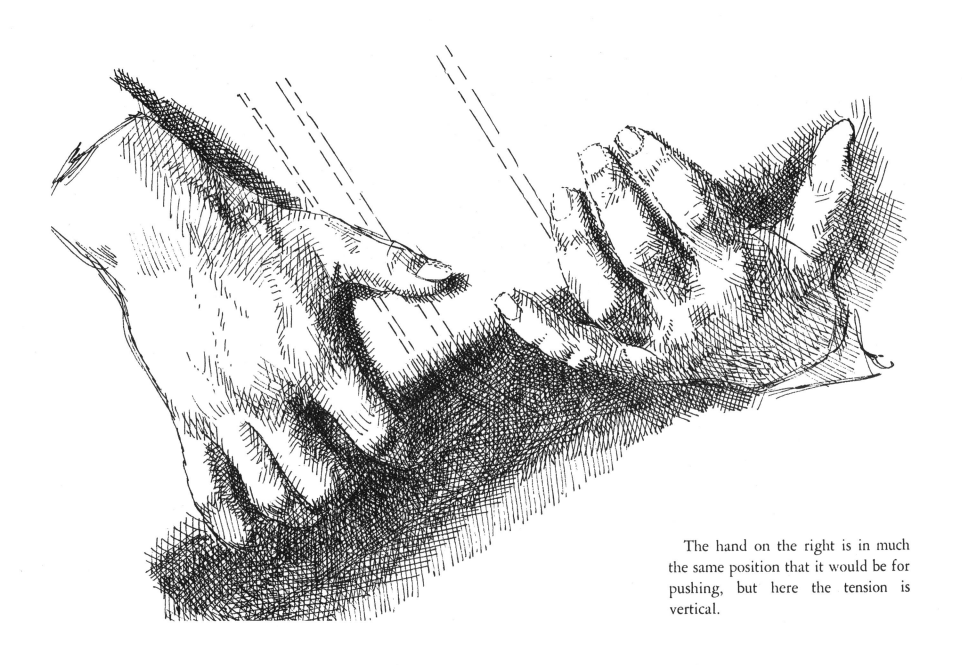

The hand on the right is in much
the same position that it would be for
pushing, but here the tension is
vertical.

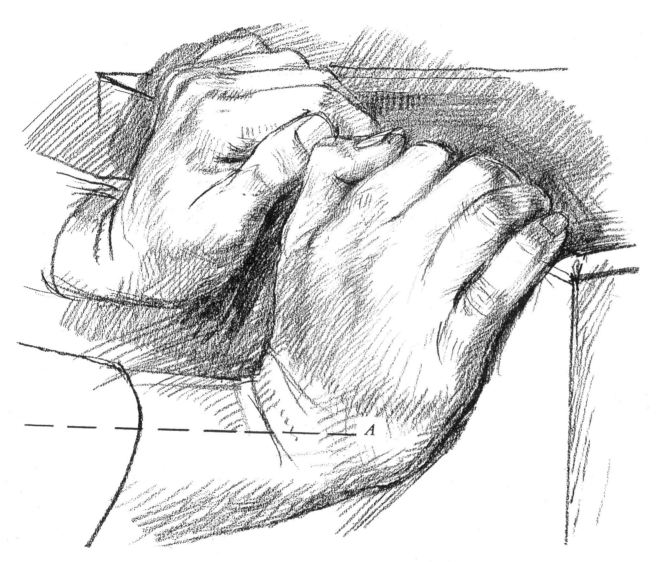

PUSHING

Pushing, when it is a question of moving heavy objects, is mainly a wrist action. From the drawing on the left it is obvious that the pressure exerted by the torso along the arms is brought to bear at point A, that part of the palm lying between the wrist and the object to be moved.

The fingers and the upper palm toward the knuckles, although carrying a fraction of the weight, are mainly bent out of the way. The fingers arrange themselves in the most comfortable manner consistent with the shape of the object on which they rest.

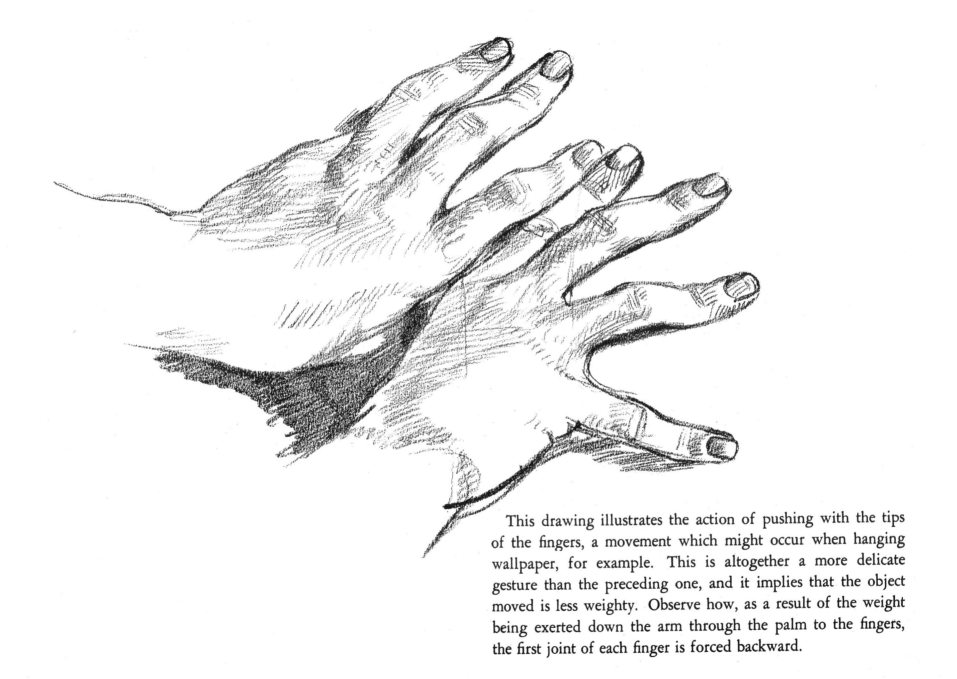

This drawing illustrates the action of pushing with the tips of the fingers, a movement which might occur when hanging wallpaper, for example. This is altogether a more delicate gesture than the preceding one, and it implies that the object moved is less weighty. Observe how, as a result of the weight being exerted down the arm through the palm to the fingers, the first joint of each finger is forced backward.

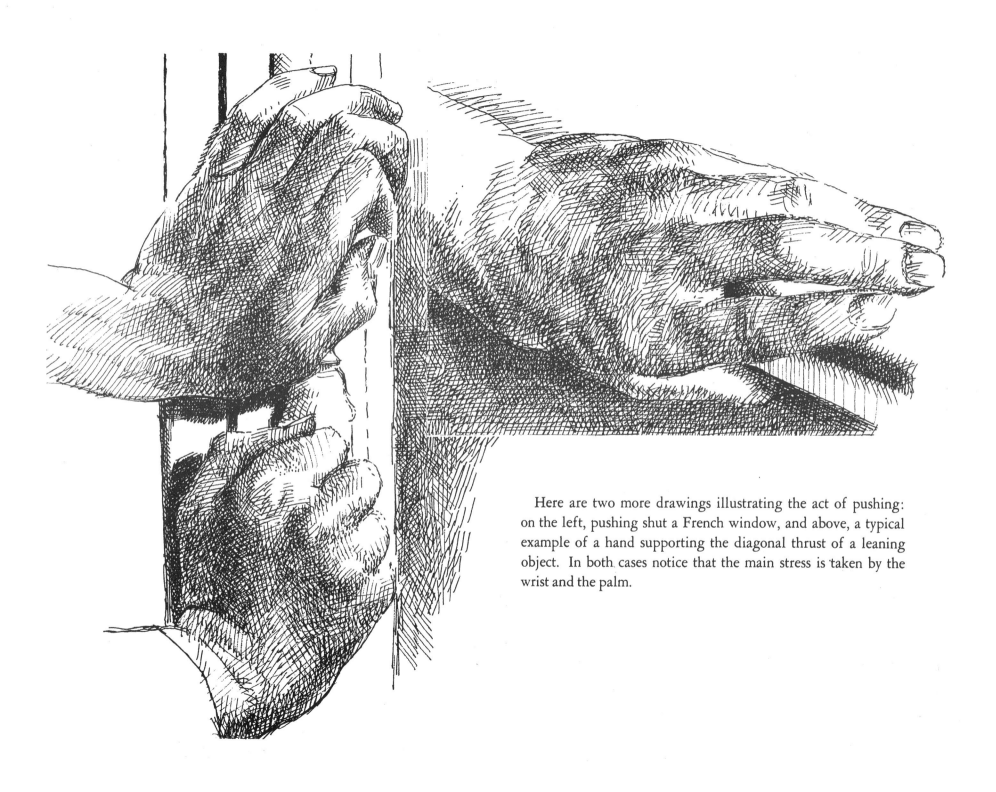

Here are two more drawings illustrating the act of pushing: on the left, pushing shut a French window, and above, a typical example of a hand supporting the diagonal thrust of a leaning object. In both cases notice that the main stress is taken by the wrist and the palm.

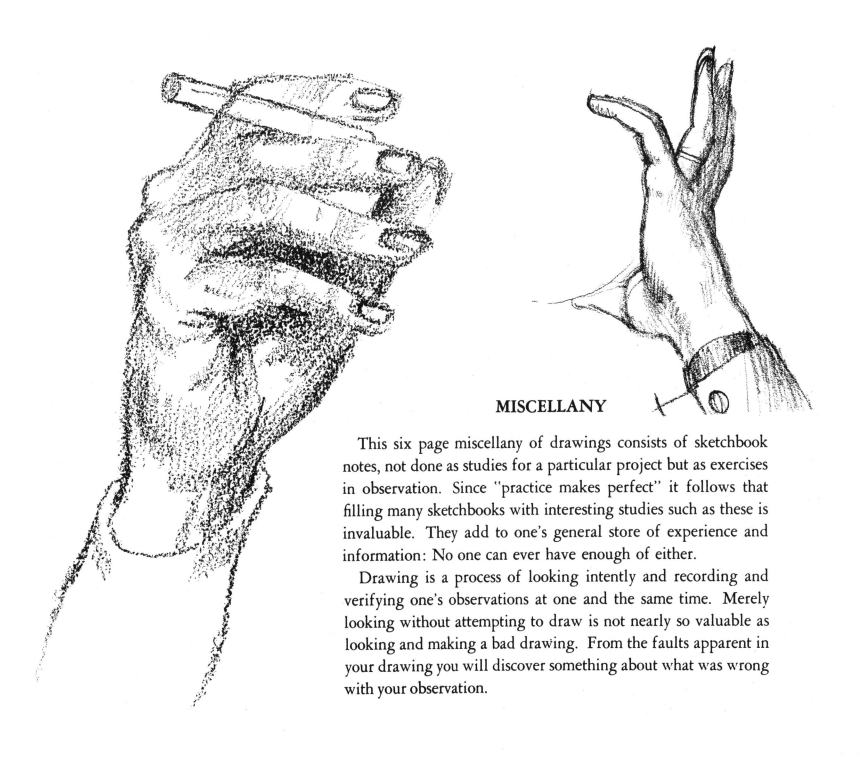

MISCELLANY

This six page miscellany of drawings consists of sketchbook notes, not done as studies for a particular project but as exercises in observation. Since "practice makes perfect" it follows that filling many sketchbooks with interesting studies such as these is invaluable. They add to one's general store of experience and information: No one can ever have enough of either.

Drawing is a process of looking intently and recording and verifying one's observations at one and the same time. Merely looking without attempting to draw is not nearly so valuable as looking and making a bad drawing. From the faults apparent in your drawing you will discover something about what was wrong with your observation.

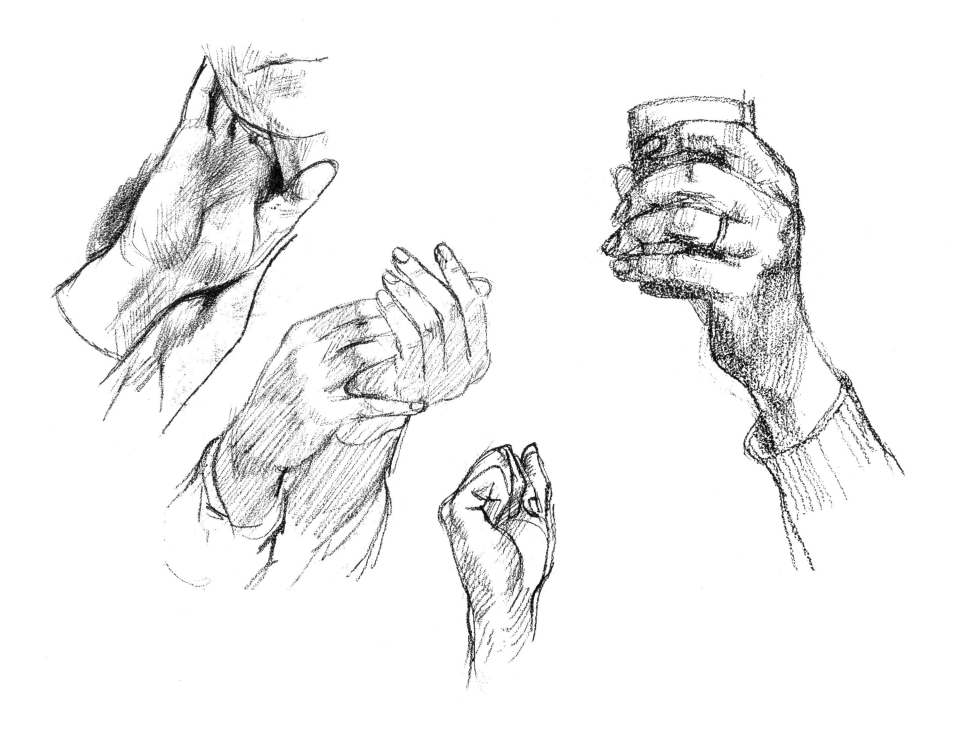

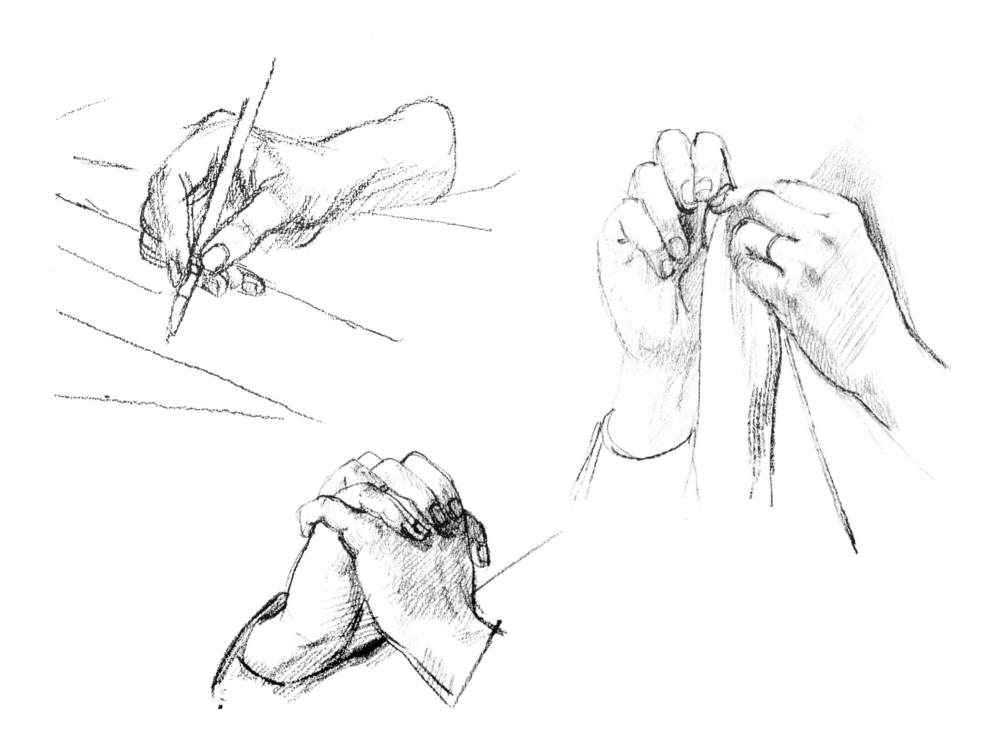

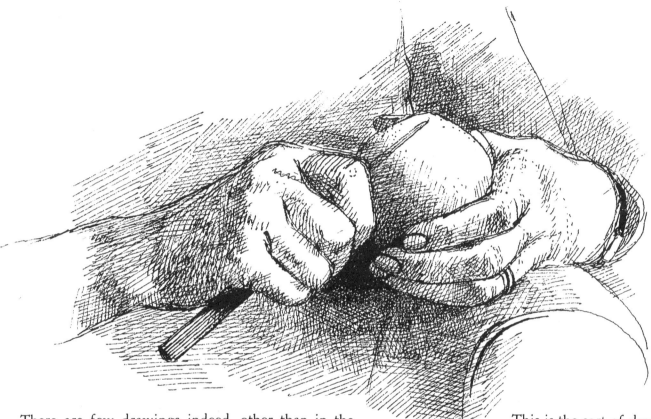

There are few drawings indeed, other than in the field of illustration, which are made to exist solely in their own right. I therefore recommend that you not concern yourself too much with "finish" of a rigid kind until you have decided which aspects of drawing are the ones that suit you. It will take a fair amount of experience before you will know for certain whether you are a linear draughtsman or one who works instinctively with a tonal sense as most painters do. For any subject at all always look at old master drawings of all kinds and periods.

This is the sort of drawing which might be made by a painter as a study for part of a particular picture. It would be made in order to clarify a problem encountered in the painting itself. Painting is a more complex technique than drawing, and it is frequently a great help to a painter to return to recording his observation of his subject in the simpler technique of drawing. In this way he is able to re-establish order in a part of his painting which has become confused and "soggy."

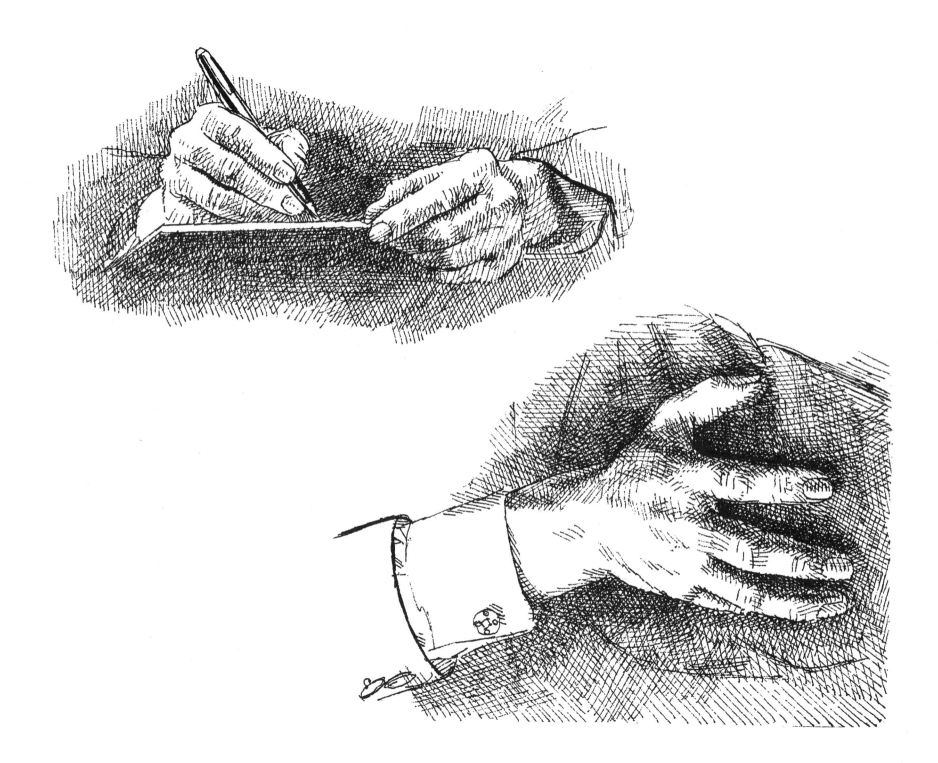

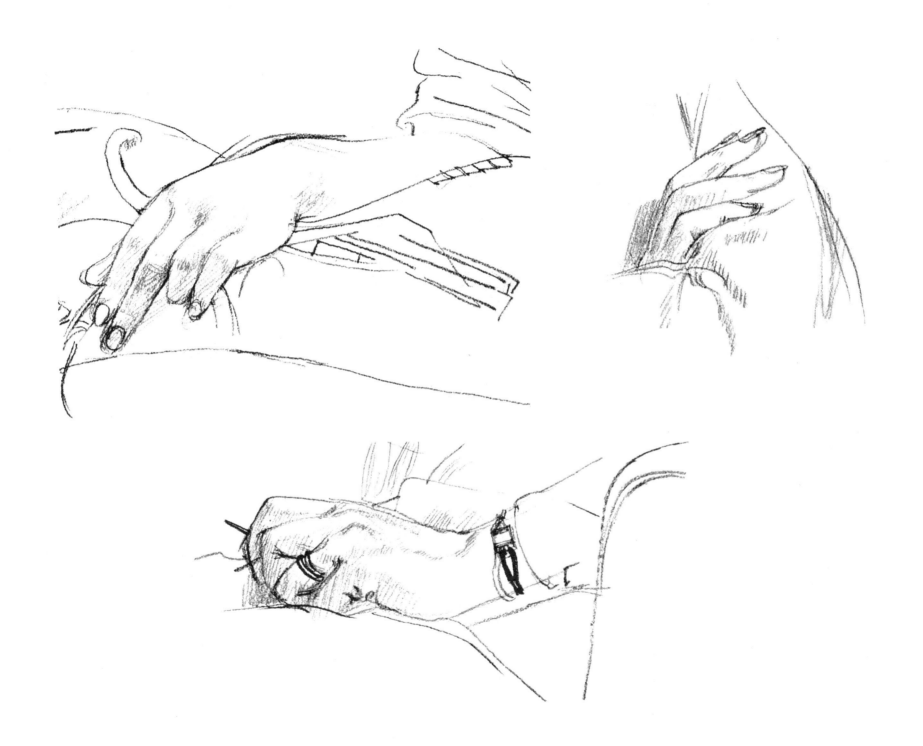

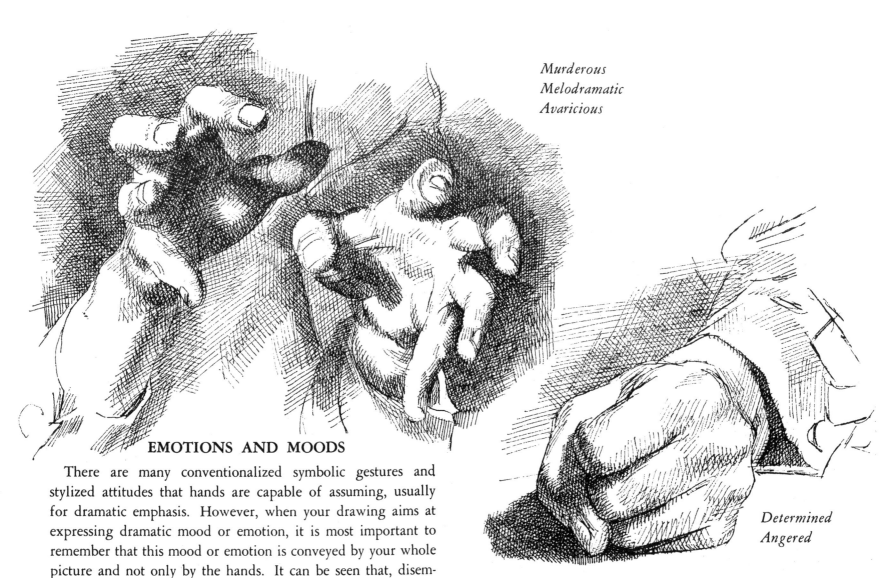

Murderous
Melodramatic
Avaricious

Determined
Angered

EMOTIONS AND MOODS

There are many conventionalized symbolic gestures and stylized attitudes that hands are capable of assuming, usually for dramatic emphasis. However, when your drawing aims at expressing dramatic mood or emotion, it is most important to remember that this mood or emotion is conveyed by your whole picture and not only by the hands. It can be seen that, disembodied as the hands on these three pages are, some if not all of them are capable of being interpreted as expressing a variety of related moods.

As an isolated unit the face is of course the most precisely emotionally expressive feature, and hands are of necessity subsidiary to it.

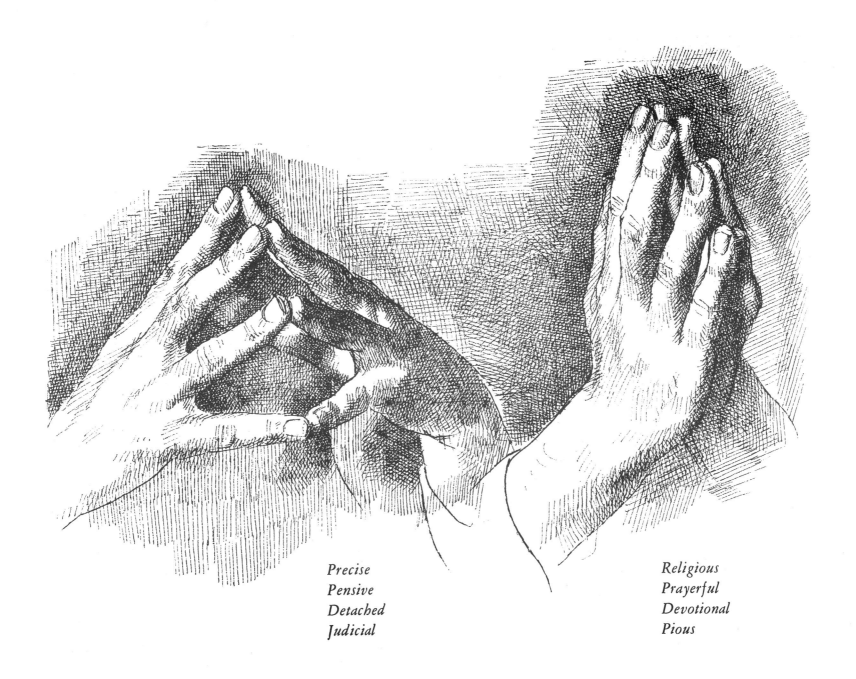

Precise
Pensive
Detached
Judicial

Religious
Prayerful
Devotional
Pious

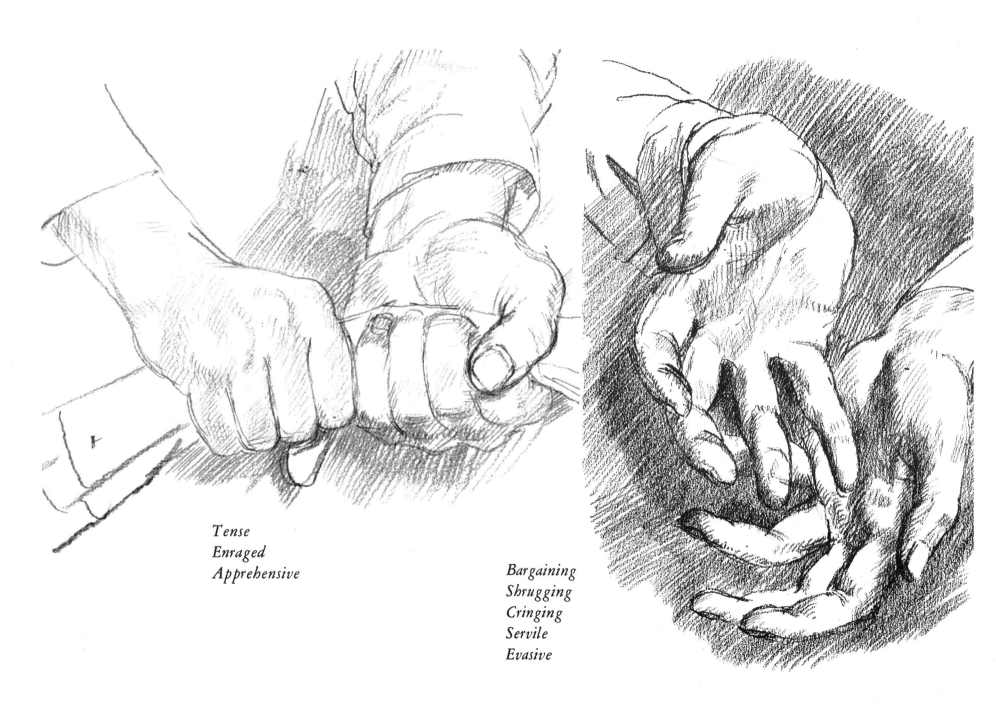

Tense
Enraged
Apprehensive

Bargaining
Shrugging
Cringing
Servile
Evasive